D0833966

HOUSE

Memoirs of a Pet Lamb

WITHDRAWN

By the same author

HENRY MOORE

INTERVIEWS WITH FRANCIS BACON

RENÉ MAGRITTE

CATALOGUE RAISONNÉ OF RENÉ MAGRITTE
(5 vols, editor and co-author)

LOOKING AT GIACOMETTI

ABOUT MODERN ART: CRITICAL ESSAYS

LOOKING BACK AT FRANCIS BACON

INTERVIEWS WITH AMERICAN ARTISTS

Memoirs of a
Pet Lamb

DAVID
SYLVESTER

Chatto & Windus

LONDON

Published by Chatto & Windus in 2002

2 4 6 8 10 9 7 5 3 1

Copyright © Estate of David Sylvester 2002

David Sylvester has asserted his right under the
Copyright, Designs and Patents Act 1988 to be identified
as the author of this work

This book is sold subject to the condition that it shall not,
by way of trade or otherwise, be lent, resold, hired out, or otherwise
circulated without the publisher's prior consent in any form of binding or
cover other than that in which it is published and
without a similar condition including this condition being
imposed on the subsequent purchaser

First published in the London Review of Books, 5 July 2001
First published in volume form in Great Britain in 2002 by
Chatto & Windus Limited
Random House, 20 Vauxhall Bridge Road,
London SW1V 2SA

Random House Australia (Pty) Limited
20 Alfred Street, Milsons Point, Sydney,
New South Wales 2061, Australia

Random House New Zealand Limited
18 Poland Road, Glenfield,
Auckland 10, New Zealand

Random House (Pty) Limited
Endulini, 5A Jubilee Road, Parktown 2193, South Africa

The Random House Group Limited Reg. No. 954009
www.randomhouse.co.uk

A CIP catalogue record for this book
is available from the British Library

ISBN 0 7011 7334 3

Papers used by Random House are natural,
recyclable products made from wood grown in sustainable forests;
the manufacturing processes conform to the environmental
regulations of the country of origin

Typeset by Deltatype Ltd, Birkenhead, Merseyside
Printed and bound in Great Britain by
Biddles Ltd, Guildford and Kings Lynn

For Peter Vansittart

I cannot recall the crucial incident itself, I can only remember how I cringed when my parents told me about it, proudly, some years later, when I was about nine or ten. We had gone to a tea-shop on boat-race day where a lady had kindly asked whether I was Oxford or Cambridge. I had answered: 'I'm a Jew.'

A good deal of indoctrination must have gone into that. Did it come from reiteration by family that I was one of the chosen people? Did it come from explanation by nannies that they went to church on Sundays because they were Christians while we went to synagogue on Saturdays because we were Jews? I had always had a double life, the one in the nursery and the one in parental

country. Corporal punishment was the pre-
rogative of my mother, who on being pro-
voked would explode, push me to the floor,
pull down my trousers and smack me at great
speed with both hands. If my father was there
he'd say repeatedly 'Leave him alone!' or,
rather, its equivalent in Yiddish, a language
he normally reserved for confidences about
money. My mother used his molly-coddling
of me – whom he called his 'pet lamb' – as
her excuse for favouring my sister, saying
that my father had so totally appropriated me,
their first-born, with his adoration that, when
they had a second child, she had no alterna-
tive to loving her more than he did and more
than she did me. She was so blithely innocent
about normal human feelings that, all her life,
when questioned about her maternal senti-
ments, she'd say: 'Well, it's natural for a
mother to prefer her daughter.' But this
preference had to be reciprocated. One day,
when my sister was very young, our mother

asked her whom she loved best, Mummy or Daddy. My sister did in fact love Mummy best but, being of an angelic disposition, lied diplomatically: 'I love you both the same.' Mummy didn't speak to her for days.

Not speaking to people for days was a habit of hers. But it wasn't always compulsive; sometimes it was calculated. Towards the end of her life she confessed to my sister how in the 1930s she would work up a row with my father which gave her a pretext for disappearing for a few days: the disappearance would allow her to meet a lover in Paris. That conversation took place after my father had died. He had made tyrannical demands of her in his last years, so that his death came to her as a liberation. She could watch television without constantly being interrupted by shouts from his bedroom to make him a cup of tea; she was free to immerse herself in reading the great Russian novels and writing a book of her own, a series of sardonic brief

lives of her husband's brothers and their spouses. She had as many visitors and invitations as she could wish, because she was immensely popular – and with people of all ages, including half a dozen grandchildren. Nevertheless, she was deeply unhappy. My father was missing.

Eight or nine months after his death she was taken to hospital with a minor respiratory ailment. She seemed to be on the mend when I went to see her one evening saying I couldn't stay long as I'd made an absolute promise to visit an artist's studio. When the time came to leave I asked her whether she'd mind if I were to go abroad shortly for a couple of weeks. 'Not at all,' she said. 'I'm not going to die now . . . But I wish I could.' When I got to the door of the ward and turned to wave goodbye, she was sitting on the bed looking like an ageing empress. Her wave across the intervening distance seemed curiously valedictory. My mission took an

hour and then I went home. Very soon a call came from my sister to tell me that the hospital had rung.

I was born, reluctantly and with resort to forceps, on 21 September 1924, which is to say that I could well have been conceived on my father's 27th birthday, 22 December 1923; my sister was born on 19 June 1927, which is to say that she could well have been conceived on my second birthday. I cannot remember at what age I made these calculations but do remember enjoying the arithmetic of the fact that my mother, born in 1901, had a birthday, 23 March, which fell just nine months before my father's. I cannot remember the date or the year of my father's or mother's or sister's death.

We moved house within a year of my sister's birth. I can remember almost nothing of the house we'd lived in previously, which was at 39 King Edward's Road, Hackney. I

know from a photograph that it was a large, dark, Victorian house, but when I went to take a look at it around 1950 I discovered that it had been destroyed in the Blitz. The other thing I know about it from photographs is that it had a billiard-room, and I have a vague memory of being in that hushed, mysterious space. I've a more precise memory of cavernous kitchens in the basement and of two women who moved about in them – Mrs Benjamin, the cook, who was massive and dressed in butcher's blue, and a diminutive grey-haired person in a drab overall called Janey, a sort of helper who may have been a poor relation. I also remember a plump middle-aged Irish nanny in a white nurse's cap looking after my baby sister and a taller and somewhat younger nanny in a felt hat who took me to Victoria Park to feed the deer.

The new house was at 78 Teignmouth Road, NW2, built around 1910 and located

two-thirds of the way between Brondesbury and Kilburn Station and Willesden Green Station on the Metropolitan Line. This was one of several neighbourhoods in North-West London to which prospering Jews tended to migrate from East London in the 1920s and 1930s, the most notorious being Golders Green, otherwise known as Goldberg Green or the Polish Corridor. We were to live in Teignmouth Road till 1940, so it is inevitable that I have been left with sharp memories of that house, but I actually suspect that my images of it were imprinted on my mind within minutes of moving in.

The entrance hall, which was big enough to contain a large fireplace, had probably been designed to be used as a breakfast-room. The first thing seen on coming in was a statue two-thirds life-size, a wood carving of a helmeted guardsman with a shield and spear standing on a pediment carved with animal heads. It was one of a number of pieces of

furniture and pictures and other art objects
which must have been acquired along with
the house. Off the hall to the left was a large
dining-room with oak-panelled walls and blue
and white china on shelves; beyond it was a
series of kitchens. Straight ahead was the foot
of the staircase and beyond it a drawing-room
with blue-grey walls and reproduction furni-
ture in a Louis XV style, including a grand
piano by Erard painted with *putti* and other
pinky figures and a bow-fronted display
cabinet containing porcelain and ivory figur-
ines. French windows led to a terrace with
steps down to a garden which had a long
lawn and a large greenhouse.

Upstairs there were five rooms. A large
bow-windowed bedroom at the front with a
huge feather-bed belonged to my maternal
grandparents. Next to it was the night
nursery, where a nanny slept alongside my
sister and me. To the side of the house was a
bedroom occupied by two maids. My parents

had a large bedroom overlooking the back garden. This had a dressing-room adjoining it which had a second door, allowing us to use it as a day nursery. It contained a bath encased in wood, with a hinged lid that made it useful as a stage but also as my sister's hiding-place for food she couldn't bear to eat. There was therefore only one bathroom in normal use and one indoor lavatory, to be shared by nine people: I don't know how we managed this, since nobody deigned to use the outside lavatory.

The most attractive member of the household was undoubtedly Grandpa. His main preoccupation that I knew of (it was only later that I knew of his love of seducing the maids) was racing. Every day when he got home from work I would go into his bedroom and sit with him while he read out from an evening paper the runners for the following day. Quite often we would all go racing on a Saturday, especially when there

was a meeting at Kempton or Hurst Park or
Windsor, and this was the one sort of family
outing I always wholly enjoyed, despite the
long intervals between races. Grandpa's own
enjoyment wasn't apparently hampered by his
being on crutches. He had been knocked
down by a car when stepping off an island in
Bond Street, just before or after we moved
house; I think it was before. It was a partial
cause of his death at the age of 53, probably in
1931, but possibly in 1930: I am certain about
the 53 because from then on my mother was
always saying that that was the age at which
she wanted to die. The shock of the accident
haunted the family thereafter. For one thing it
made my father utterly obsessed with our not
getting run over. Every time we left the
house, even in my adult years, it was: 'Be
careful how you cross the road!' I was to nag
my children in the same way. It is true that
neither my sister nor I nor her children nor
my children ever were run over, but the

pressure has left me neurotically cautious about crossing the road. It also led to torture at school. My prep school was a fifteen-minute walk from home with only one main road to cross, but my father insisted on my being accompanied there and back by Nurse till I was 11, and the other boys made me pay heavily for that.

Another obsession sown in my father's mind by the affair was that it was difficult for Jews, especially immigrants, to get justice in the courts. The family were, of course, convinced that the motorist had been to blame, but in any case Grandpa was a hopeless witness because he spoke English badly with a strong foreign accent: I was told the judge had bullied him as if that was his fault, which doesn't sound implausible. I was to hear about that again and again, especially whenever the subject of the law came up. The one thing I didn't hear about was that Grandpa had died. At the time it happened I

was told that he had gone abroad to be with
his own family. I somehow accepted it as
normal that Grandma had stayed on with us
and that we never got a letter from Grandpa.
I learned the truth when Grandma died in
1935 and someone else's nurse told me how
ridiculously ill-informed I was not to know
that my grandfather had gone long ago.

I got on quite well with Grandma, too. She
was the ideal opposite of her husband: sober
and dignified and quietly authoritative. She
didn't talk a lot, never mentioned family
matters to me, often spoke of her love of
Rudolph Valentino. Her time was filled by
three activities. She was a wonderful cook of
chicken soup, barley soup, matzo balls, gefilte
fish, heimishe fish – fried fish to be eaten cold.
She sat reading Yiddish books and news-
papers. And she played patience, the cards
spread out on the dining-room table. She
taught me several varieties and I became
and have remained so addicted that for

decades I've not dared to have cards in the house.

These grandparents were the Rosens. His first name was Jacob; I cannot recall hers. They had come to England from Eastern Europe in the 1890s. She was not purely Jewish because a rape two generations back had infused her with Tartar blood. Settling in Whitechapel, they had had three or four children, two of whom had survived: my mother, named Sarah, which she changed to Sybil, to her later regret, and her younger brother, Montague, called Monty. Grandpa was a fishmonger. In the early 1920s he had had an offer from a friend in the film industry, Jack Hyams, to become a partner. Had he accepted he'd have owned a large share in Gaumont-British, but he hadn't been prepared to take the risk of moving into unknown territory. Within his familiar trade he had done reasonably well in a modest way, owning two or three shops, moving upwards

domestically, ensuring that his children were educated: Monty was taught to play the cello; my mother learned the piano, painted convincingly in watercolours, wrote good clear English prose, and was trained as a shorthand typist and book-keeper. When she got married in her early twenties, she went into her father's business, behind the cash desk. I don't think it ever entered her mind that she might stay at home and do some cooking or spend some time looking after her children.

She'd go to work in the morning around nine. She'd spend the afternoon in town or at a swimming-pool, come home to do the books and visit the nursery for a moment before dinner. In school holidays I saw more of her: we'd go frequently to Wembley Pool in the summer and in the winter she'd take me with her to the West End once a week, to shopping at Selfridges and tea at the Cumberland or the Regent Palace, often together with some gentleman friend. In the evening she'd

go out to the pictures or the theatre or a whist
drive or a bridge club. Her leisure activities
tended to be different from my father's. She
was good at cards; he didn't play at all. She
loved swimming; he couldn't swim. She was a
wonderful dancer; he didn't dance. Every
week or two I'd see them dress up together,
him in white tie and tails, for some evening
event, often a charity ball, but I doubt
whether they ever took the floor together; I
imagine that she danced all night while he sat
talking. There were some things they did
together, including, she later told me, often
making love ('I can't complain about him on
those grounds'), riding, golf, racing, motoring
(he had always been a driver; she learned late
and drove much better). And they went
together to the cinema and sometimes the
theatre or opera or ballet, though not to
concerts, other than charity concerts, but
while she became a fervent balletomane, he
loved Italian opera, especially when singing it

himself around the house. He must have loved the sound of his own voice. With the possible exception of riding – which he did every Sunday morning on Rotten Row – talking seemed to be the activity he liked best. He sat on committees, he made speeches, and he prayed aloud, as Jews do, at length. There is little doubt that he should have been a rabbi.

He had had a fanatically Orthodox upbringing by a father with rabbinical ancestry and a patriarchal presence who was one of the more palpable carriers of the madness that ran in the family. One day, when approaching puberty, I was present at some sort of gathering at his house and received a message that Grandpa had something he wanted to tell me. I approached his throne, a rocking-chair, with trepidation. 'Always remember this,' he said with solemnity. 'Be careful of girls. Don't get too near them.' I had no idea what he meant and remain unsure.

The effect of my father's religious educa-
tion was manifestly diluted in the early days
of his marriage by the civilising influence of
his father-in-law's easygoing attitudes; other-
wise my father would not have gone racing
on the Sabbath. But Grandpa Rosen's death
and its causes brought back the fear of God.
This was very bad luck for me, because it
meant that the crucial years of my upbringing
were spent in a deeply oppressive atmosphere.
Every Saturday morning – and on quite a few
weekdays in the course of a year – I had to
go to synagogue and spend at least three
hours there. On Saturday afternoons it was
forbidden to write or draw or play the piano
or cards or ball-games or to go to the cinema.
And on Friday afternoons in midwinter, the
season when the Sabbath came in early, my
school was instructed that I had to leave the
football field at 3.30. There were plenty of
other Jewish boys there – the school was in
Brondesbury – but I was the one who bore

the brand. Was my father even aware of what a sissy I was constantly being made to look by his beliefs? If he had been, would it have made any difference? As if the tedium and embarrassment of restrictions were not enough, I also had to endure the tedium of his endless preaching about the Almighty and the embarrassment of his mocking diatribes against the heretic *Yoshki*, i.e. Jesus Christ.

There was one afternoon when both my parents excelled themselves in complementary ways. The occasion was a party at the house, a party for my birthday; it would have been my 11th or 12th. All the guests were boys and things got rough: at one point I was subjected to a violent ragging that made me feel I hadn't got a friend in the world. Later there was a lot of rushing about that I certainly couldn't control and didn't even desire. A nice boy called Alan Mindel slipped on some polished linoleum as he raced around, hit his chin on the veneer of a rosewood dressing-

table, and had to have a couple of stitches put in. My mother reacted with fury and gave me a beating in front of several guests. My father reacted with guilt and sought to placate Mindel, or his parents, by giving him a pair of white mice which I had received two days earlier as a birthday present. The deed was done behind my back; I was told about it after the party, without any apology.

Like my mother's parents, my father's had come to England from Eastern Europe in the 1890s, though not before going very briefly to America. When asked for his name by an immigration official, my grandfather uttered something unpronounceable beginning with a hiss and the name of Sylvester was conferred on him. His wife was Rose Waxman, a sister of two leading Yiddish actors, Maurice and Fanny Waxman, whose roles on the London and New York stages included Hamlet and Medea. My father was

born in Newcastle-upon-Tyne, grew up in Darlington, and always had a slight Northern accent. He was one of a large family: Abe; then Bec, the one girl; then my father, Philip, called Phil but Phishel at home, from his Hebrew name, Feisal; then Jack, Harry, Sid, Dave and Louis. Their father was a tailor, one who earned too little, with all those mouths to feed, to be able to buy shoes for his children to wear to school. At 13 or 14 my father got a job in a billiard hall, and thereby became a useful player. When war broke out in August 1914, he volunteered, while still 17. His regiment was the Royal Artillery. He was in France and Flanders for four years, and was then invalided out suffering from trench feet.

Enlisting in the Army may have had a special significance for him in that it related to an element in his heritage of which he was as proud as he was of its rabbinical component: a recent forebear, he often told me, had been

an officer in the Russian Army. My father's
obsession with his Army life was far more
interesting to me than his obsession with
Jehovah. He was always talking at length
about his experiences at the Front, but he did
so with eloquence: he could bring back
Passchendaele in all its horrors without
showing self-pity. Much later he made several
appearances in a BBC TV series on the Great
War.

Nevertheless, I wonder about his Army
career. He was out there for four years, with
people dying like flies, yet the only promotion
he ever got was from driver to signaller. He
did often say that he'd been cheated of a
medal he deserved because he'd been too
diffident to speak up about his bravery, which
is plausible: for instance, when joining the
Army he had dropped the name Sylvester
because he thought it was too showy and
adopted the duller name of Silverston. But it
seems curious, seeing he was an enthusiastic

as well as a long-serving soldier, that he failed to get a stripe. Was it because of anti-semitism? Though he constantly spoke of anti-semitism in other areas, he didn't do so when talking about the Army, not even volunteering anything about whether his comrades were anti-semitic, which they probably would have been, and one never asked him anything about that because he might have had painful memories. What is certain is that there was something deeply unfulfilled in his loving feelings about Army life. And I was expected to compensate. From the age of 11 I was taken to the barber's by my father rather than Nurse so that he personally could give orders in the right kind of voice that the cut was to be 'short back and sides'. Then, when I moved to my public school and had to choose from several possible activities for Monday afternoons, the Officers' Training Corps was the choice made for me by my father. He also obliged me to join the School

of Arms, where I boxed rather than fenced, because he had been coached when in the Army by Bombardier Billy Wells, the some-time British heavyweight champion.

My upbringing, in short, was a preparation for two alternative roles: devout Jew and British Army officer. This seems to have been foreseen from the time of my birth, for they gave me a couple of good Jewish names, David and Bernard, but preceded them with Anthony. I was always called Tony. This perhaps went well with the sort of role my mother wanted me to play. When I was eight she said she would like me to have a career like Noël Coward's; later she suggested that I might become a couturier. My sister was named Jacqueline Ruth: in later life her friends called her Jackie, but at home she was always Jac.

When my father came out of the Army he got into the same kind of work as

all his brothers. At first, Abe, the eldest, decided to be a dentist and changed his surname to Murray so that he wouldn't appear to be a Jewish dentist, but he found he was too squeamish about working inside people's mouths and went the same way as his brothers. All seven of them must have inferred from their father's career that it didn't pay to be a craftsman; all seven of them became dealers, most of them wholesalers, in goods such as clocks and watches, cutlery and jewellery. My father had the wit or, rather, I suspect, the idealism to choose a more distinguished field: philately. He got a job in the Strand with Fred Melville, one of the two or three most reputable of London stamp dealers. He loved the work, and indeed remained a stamp collector all his life. Melville gave him every encouragement and he had no desire to leave, but he had to when he married my mother.

One day, late in my parents' lives, I was

sitting at a table with them and other members of the family having an unusually amiable conversation. We were talking about the polarity between Phil and Sybil's temperaments and, as Phil for once seemed prepared to talk about what others wanted to talk about rather than what only he wanted to talk about, we asked him to tell us what had made him choose a wife as flighty as Sybil. He answered that, after coming out of the Army, he had tended to feel very depressed and that, when he met Sybil, he was enchanted with her gaiety and wanted to be with her because he hoped that some of it might rub off on him.

He paid a heavy price for marrying her: it entailed going into her father's business. And so he became a fishmonger, getting up at five in the morning to go to Billingsgate Market and working till about four handling smelly, slithery goods and customers who haggled over prices and delayed settling accounts. He

found it a dirty, unpleasant, undignified job, but he was forced to pursue it for nearly twenty years until in 1940 he went into the same sort of trade as his brothers. And his children found it inglorious. It was very nice to have fish liver or chitterlings for tea all the time, and large portions of carp at family meals during Passover, but it didn't compensate for the shame. In the course of my life I twice received nasty shocks from literature: the second came at the age of 17 when, having fallen in love with 'The Hollow Men' and 'Ash-Wednesday', I bought Eliot's *Collected Poems* and came upon Bleistein and Rachel *née* Rabinovitch; the first had happened at the age of ten when on my first visit to the Old Vic I saw Hamlet debunk Polonius by calling him a fishmonger. And then at school one day each member of the class was asked to say in turn what his father did and, when it came to my reply, everybody tittered.

My father's distaste for his work meant that

his best energies went into his spare-time occupations. Their nature was determined by the intersection of two co-ordinates: his obsession with Judaism and his love of talking; or, rather, his love of discourse. For it wasn't just speech that delighted him: he loved *words*; this made him, for example, a manic punster. So the love of discourse encompassed writing too. I don't suppose he was ever paid for a piece of writing: his publications were letters to the editor, mostly in the *Jewish Chronicle*, but occasionally in national newspapers. Sometimes the topic was theological, and here he was always rigorously Orthodox. Usually it was political, perhaps about anti-semitism somewhere, but mostly about Middle Eastern problems, which he approached from a passionately Zionist standpoint. He was also very active in Zionist organisations, holding positions such as, if I remember rightly, Vice-Chairman of the London Regional Council of the Zionist Federation.

He was also the composer of a Zionist march. Around 1935 he wrote the words and music of a song or hymn entitled 'Israel Home of the Free', which is to say that he wrote the words and sang the melody to a musician who transcribed and harmonised it. He then got a friend to do a translation into Hebrew of the words. He then persuaded Boosey & Hawkes to publish it. He then persuaded Paul Robeson to perform it at a concert in London. But now his military fixation intervened and he started to hear the music in his head at a faster tempo, as a march played by a military band, especially by trombones. He added a bridge passage, had the piece orchestrated, and renamed it 'Israel'. He persuaded the organisers of the annual march of Jewish ex-servicemen to include it among the music played by the band as the ranks of veterans proceeded up Whitehall wearing bowler hats and medals. And he

persuaded a major record company to release
a performance of it by the band of a Guards
regiment. It was a habit of his to quote out of
nowhere and out of context the lines from
Henry V, 'In peace there's nothing so
becomes a man/As modest stillness and
humility', and I do think that most of the time
he behaved as if he believed this, but there
were some concerns about which he could be
pushy with a persistence devoid of all shame.
In the case of his march he got his rewards.
After the state of Israel was established, the
march was often played there – and perhaps
still is – on ceremonial occasions along with
the national anthem, almost as 'Rule Britan-
nia!' is played here. Where the analogy falls
down is in that the two British tunes are alike
in atmosphere, whereas the Israeli anthem,
the 'Hatikvah', with its plaintive tune resem-
bling a theme from Smetana's *Ma Vlast*, has a
decidedly Jewish or Slavic flavour, while
'Israel' is musically about as Jewish as 'The

British Grenadiers'. Though my father was a fanatical Jew ideologically, spiritually he belonged to England. This no doubt was why, when he visited Zion in 1947, he hated it and never went again.

But he also got involved in British politics. Shortly after its formation in 1930, he joined Oswald Mosley's New Party. There's a photograph of a weekend gathering at Mosley's country house in which he is seated on the lawn as one of an assorted company of prospective Parliamentary candidates, including John Strachey, Harold Nicolson, Peter Howard and Professor Joad. Three years later, when Mosley was starting to move towards Fascism, there were some letters, which are extant, in which my father sought reassurance from Mosley that his brand of Fascism was not anti-semitic and someone replied giving him reassurance. Most of my father's interventions in British politics were on behalf of Jewish interests.

After the war, while remaining a deter-
mined practitioner of the Jewish religion, he
didn't resume political activities. This was
probably because he was now doing work
that interested him. He and my mother were
building up a business in Chancery Lane with
the strange name of Marshal's (with one 'l')
Antiques Ltd, a name dreamed up by my
father purely for the sake of its allusion to the
military rank of marshal: unsuspecting of his
madness, some customers addressed him as
Mr Marshall. There were two branches, a
shop run by my mother dealing in silver,
mostly Georgian, and one run by my father
dealing in miscellaneous antiques and bric-à-
brac. She revelled in her job, especially the
buying, which she did with a lot of taste. She
was hampered by suffering from angina,
which gave her hope that she would not have
too long to live with the guilt she felt from
1954 on for having survived longer than her
beloved father. In the end she found herself

still going to work in her mid-seventies, despite having difficulties with walking. One thing that kept her going seemed to be her joy in being able to tell me that she could make more money going into the shop for four hours a day than I could as a writer working two or three times as long: it was like her permanent love of reminding me that she could always trounce me at cards. I think she would have gone on till she dropped had she not generously closed the shop to preclude encumbering her heirs with the problem of deciphering her book-keeping.

My father did not begin to match her talent for business. Besides lacking the realism of the businessman, he also lacked the flexibility; he suffered from fixed ideas, so that, for example, gold having been an excellent medium for investment before the war, he made heavy long-term investments in it after the war which turned out to be unprofitable. And, besides lacking the realism and the

flexibility, he also lacked the ruthlessness. Unlike most of his brothers, he refused to save his skin by going bankrupt at some stage in the 1930s: he could have prospered by taking that course, but he insisted on settling his debts, borrowing money to do so at high rates of interest. He was a man of honour.

As to fixed ideas, he had these in other areas too: for example, in that of life and death. Being a great believer in Holy Writ, he accepted that the proper span of a man's life was three score years and ten. When he got to 70, he therefore closed his shop and more or less retired to bed to await the Angel of Death. The wait depressed him and he started rotting away. When he reached 80, though, he suddenly realised that in his case Holy Writ had got it wrong and felt very pleased with himself. So he started to re-engage with life and found himself a new cause. His local synagogue was increasingly lending or renting space for Masonic meetings. My father

decided to wage a campaign against what he saw as an abuse of the synagogue's premises, a cuckoo in the temple of a proper religion. I do not know how pure his motives were, and hope they were not simply resentment at not having been asked to join, but the passionate polemical battle he fought did bring about a measure of change. I think it may well have been this affair that led to my mother's crystallisation shortly before he died of the true nature of 'Phil's tragedy'. His trouble was that, while he had given his life to Jewish activities and causes, he happened to hate Jews. He didn't like being with them, he found them vulgar; his few real men friends had all been *goyim*; the times when he was happiest were when he was talking to *shikses*, making up jokes and puns and charming them.

Phil was not only a charmer of pretty girls; from time to time I come to meet some eminent lawyer or banker who asks me

whether my father had an antique shop in Chancery Lane and goes on to tell me how much he liked him. He was as much a charmer of all strangers as he was a tyrant at home. Although my mother's illumination made him more sympathetic, I failed to the very end to come to terms with him. When he was on his deathbed, he somehow managed to provoke me to lash out at him so that he landed on the floor, poor sod.

The first nanny I remember at Teignmouth Road, after the one in the nurse's cap, was a German girl called Ada. I liked her and so did my sister. On long walks to Gladstone Park she'd tell me the story of the *Ring*. It was very exciting, and Hagen seemed the most evil and frightening person ever. Jac and I must have been sad when she left because we were very exacting about her successors. There was one memorable incumbent who arrived one evening to take up her

duties and somehow got so far on the wrong side of us – perhaps by seeming defenceless – that we formed an immediate tacit agreement that she must go. We ragged her so mercilessly all night that she packed her bags first thing in the morning; my mother gave me one of her worst beatings. We then had two French nannies. One was called Mademoiselle, and I think our mother quite soon got rid of her because my father fancied her. The other was Yvonne, who didn't survive because I teased her too much.

And then someone arrived who took firm and friendly control, stayed about six years, was liked and respected by me, adored by my sister, and only left because the war broke up the household. She was in her mid-twenties, slim and dark, with glasses, and was called Emily Tomalin. Her previous job had been as a nurserymaid with Sir Abe Bailey, a South African baronet I strongly approved of because he both owned good racehorses and

had a private cricket ground at his country house. Jac called her Nanny, I called her Nurse, and neither of us minded taking orders from her. Sometimes she got it wrong. In her teaching of verbal manners she told us to say 'Pardon?' rather than 'What?' and in her teaching of table manners she may not have been right about which way to tilt a soup plate. She was keen on table manners but not as keen as she was on making us eat up, and her insistence over this was her one major fault. When we had lamb chops – once or twice a week – every bit of lean meat had to be consumed; I hated that sliver of lean sandwiched between two slices of slimy fat, but she would never let me leave it. She had two arguments for this: the amount of money my parents were paying for the chops, and all those poor starving children in Africa. Milk puddings were almost worse. There were some I positively liked – rice and macaroni and blancmange – but others were sickening:

semolina and sago and tapioca (slime again). I wasn't fooled by her excuse, 'Milk puddings are good for you,' because she could have told the cook to confine ours to the ones I liked. I knew that what she really believed was that eating sickening things was good for our souls.

We spent a lot of time together at table, Nurse and Jac and I: breakfast, lunch and high tea every weekday even in term-time, because my father wouldn't let me have school lunches as the food wasn't kosher. This meant that my lunch break consisted of two walks and a meal with an eye on the clock, and no time at all for play. On the other hand, lunch with Nurse was quite enjoyable because I liked hearing her hold forth, say, on the novels of Ethel Mannin and Naomi Jacob or about Jessie Matthews in *Evergreen*. On a really good day the subject would be some family matter – a bit of scandal or, better still, discreet criticism. But

she could also be fascinating in the public
domain. She was in especially good form on
the day when Edward VIII was about to
abdicate. The question was: who would Mr
Baldwin allow to succeed him? It couldn't be
the Duke of York because he stammered. It
couldn't be the Duke of Gloucester because
he had no consort and anyway everybody
knew he was stupid. So it was going to be the
Duke of Kent and Jac and I said hooray
because he was our, as he was everybody's,
favourite royal.

There must have been many outings with
Nurse, but I can remember only one of
them. It was among the most crucial outings
of my life: my first cricket match. The year
was 1934, when the Australians were here for
the first time since the 'body-line' tour down
there. I had lately become aware of cricket
and had quickly read a great deal about it. I
asked my parents if I could be taken to see a

game, especially as Lord's was quite near. I
realised that it would be almost impossible to
get into the Test match there against Australia
– though later that summer my father himself
took me to the Test at the Oval and as we
couldn't get tickets for seats in the ground,
cleverly found us seats in the window of a flat
overlooking it, from which I saw the first fifty
runs of a Bradman innings. The sport he took
me to of his own accord, apart from racing on
the flat, was boxing, on Sunday afternoons at
the Ring, Blackfriars, especially when Jack
'Kid' Berg was fighting.

For that visit to Lord's with Nurse, I chose
the annual contest between Gentlemen and
Players, which meant that I would be seeing the
best English amateurs of the day play the
best English professionals. When I saw C.F.
Walters open the Gentlemen's second
innings, I showed a precocious connoisseur-
ship in realising that I was seeing batsmanship
at its most stylish, so that he became the first

of my Arcadian heroes at Lord's.

My preferred sports and games were mostly clear to me by the time I left prep school. I've never much wanted – though I've done a bit of some of them – to run, jump, swim, box, ski, row, boat, ride, fish or shoot game, and I drive too badly to do it, though I enjoy watching other people run, box, ride and race cars. But there's scarcely any ball-game that I don't enjoy obsessively. I've played and watched cricket, tennis, rugby, soccer, golf, snooker and table tennis – the one game I've played moderately well. But cricket is the game that has mattered. The one real ambition I have ever had was to play first-class cricket.

Besides endlessly playing and practising, I went to first-class matches, listened to running commentaries on the wireless, walked round to an uncle's house to watch Tests on their television set. I constantly read books about the game or studied its statistics in

Wisden. When I could find an opponent I played a table game called Stumpz. When I couldn't, there were solitary table games I had invented using dice or playing cards to produce fantasy matches, the progress of which I recorded ball by ball in a score-book. Day after day of my time was given to cricket, real, chronicled and imaginary.

Sunday afternoons, though, like the Saturday mornings spent in synagogue, were times rudely subtracted from cricket and everything else worthwhile. My parents and sister and I, and sometimes further family or friends, would get into one or two cars and drive off towards the west. The drive often made me feel or be sick. Sometimes we'd stop off at a roadhouse, the Spider's Web or the Ace of Spades, places which were lent glamour by their names. Sometimes, especially when there were foreigners aboard, we'd stop to admire a view which everybody said was beautiful. The destination was always some

boring spot on the Thames, such as Maiden-
head or Runnymede. We'd sit on the river-
bank and some of us would take a swim, but I
hated swimming in a river as it held neither
the charm of the sea nor the clear water of a
pool. Then we'd have tea at some dreary
establishment. And then we'd get some ice
cream, and all that I was allowed was half a
so-called brick between two wafers: I wasn't
allowed a whole brick because ice cream
wasn't good for me. And then we'd drive
home. The nearest thing to interest offered by
these drives was spotting the makes of the
cars seen on the road. But this seemed an
insufficient reason to be there. It was all the
more puzzling in that there were other
outings that had some purpose.

The first visit to a cinema I remember was
around 1930 to see *Trader Horn* at the Empire,
Leicester Square. As we entered the audito-
rium in the middle of the film the screen was
filled by a rhinoceros in profile which was

shot an instant later and very slowly collapsed
and died, still in profile, as we watched. A
film seen not long after left vague but
haunting images of masses of Chinamen
running at top speed through the alleys of a
town: was it funny or frightening? But in 1933
I carried away precise memories of *42nd
Street*: of Warner Baxter as a famous stage
director in the shadow of the Depression,
desperate but still mesmeric; of Bebe Daniels,
slinky and haughty but enslaved by love,
giving the perfect rehearsal – preceded by
'Jerry, put it up a half a tone, will you?' and
punctuated by a catlike spring onto the piano
– of a perfect song, 'You're getting to be a
habit with me'; of fresh-faced, winsome,
whiney Ruby Keeler clunking her dancing
feet across the stage; of the luminous ge-
ometry of Busby Berkeley's shuffling of
desirable bodies. What was beyond me then
was the mordant realism – shortly to be
precluded by the Hays Office – of the

handling of the business between backers and troupers. *42nd Street* stayed in my mind as my favourite musical and its song about addiction as my favourite song, and many later viewings have confirmed these preferences. With a start like that to my watching of films, it is not surprising that this has been one of the most time-consuming activities of my waking life.

Nevertheless, the early cinema-going also initiated a bad habit. When I was nine or so I saw a B-film in the company of my mother which was about a separation between a mother and a son who must have been around my age. It was called *Reunion* and at the end of the film mother and son were reunited. I cried. My mother was greatly touched by this and made appropriate noises. From that day on any reunion on any screen has unleashed floods of tears, and so have all other scenes on comparably kitschy themes. If I watch films on television along with other people, I have to place myself in the room strategically so

that my shame will not be visible to anyone else. On the other hand, in life, when there is something real to cry about I am often unforthcoming. But music can intervene to turn on the tears as readily as urination is stimulated by the sound of flushing water. I remember a funeral at which I thought I ought to have been crying without managing to, until some tear-jerking music made the tears unstoppable. And with the cinema too music is often the most powerful stimulant: I watched *The Diary of Anne Frank* for a time without tears until the arrival of some soupy music left me with two sodden handkerchiefs. So I am manifestly one of a host in whom tears are a cheap commodity. It always surprises me, therefore, when intelligent people talk with self-satisfaction about having been moved to tears by some work of art. For tears are a low-level response to the arts. The authentic responses are to feel pierced or set alight or elevated or torn apart.

My parents also chose some impressive theatrical visits, starting in 1935 with Maurice Evans in *Hamlet* at the Old Vic, followed there by Laurence Olivier in *Macbeth* and, at the Golders Green Hippodrome, by John Gielgud in *Richard II*. I was also taken to things picked out by myself: the Crazy Gang in *OK for Sound* at the London Palladium and Eliot's *Murder in the Cathedral*, after I had heard part of a broadcast of it. I found it long, apart from the murderers' apologias, but was touched that my father had put up with all that Christianity for my sake.

My mother was by then going to the ballet at least three times a week, usually in the gallery at Covent Garden. She took me with her several times: among the pieces I liked especially were *Les Sylphides* and *L'Après-Midi d'un faune*; my favourite dancers were Baronova, Danilova and Massine.

I had read Arnold Haskell's *Balletomania* before ever going to the ballet and now I

reread it constantly. Of course I was always reading about the forms of entertainment I enjoyed, but Haskell's book fascinated me above all. One haunting passage was a breathless description of Diaghilev's late night visit with Larionov to the Moscow studio of the young Goncharova, where, after examining the canvases by candlelight, he commissioned the designs for *Le Coq d'or*. This was the nearest I came to any intimation that my life might connect with the visual arts.

Meanwhile my taste in fiction was limited and childish. My mother tried to interest me in things like *Pickwick Papers* and *Stalky & Co*, but I couldn't get involved; I found their humour ponderous. What I liked spontaneously was the fantastic, in some form or another. Above all, the *Alice* books; then *Arabian Nights*, Arthurian legend, *Gulliver's Travels*, Hans Christian Andersen and Scott Fitzgerald's 'The Diamond as Big as the Ritz'. The reading I found indispensable, though,

was the non-fiction connected with games and dance and movies and the like: it seemed so natural to be moving between watching such events and reading about them. And then one day I found instinctively that it seemed natural to move between watching such events and writing about them. At the age of 11 I saw my first game of league football, in which Arsenal beat West Bromwich Albion 4–1 at Highbury. When I got home I felt bound to write a report about the match, and this got published on the children's page of a local periodical. The pattern of my future life was set on that day when, having been one of the spectators at an event intended to provide an aesthetic experience, I found that the experience was not complete for me until I had tried to put it into words.

I was present at Highbury that day thanks to my mother's younger brother, Monty, her one sibling to survive childhood, a young

man who made her formidable will to please herself seem almost restrained and who happened in various ways to play a key role in my education. I was about four when we started sometimes going to tea with him and his wife Cissie on Sundays in their flat over a shop in the Finchley Road. When nobody was about he'd pick me up and hold me by an arm and a leg out of the window above the street, not concealing his delight in the hopelessness of my entreaties to be brought back in. It may be that this habit of his had some relevance to the growth of a phobia that later deterred me, on a visit to the Grand Canyon, from coming within ten yards of the edge.

Generally, though, Monty's effect on my life was positive, especially during the period of mourning for his mother which began in the spring of 1935. According to Jewish rules, a bereaved son is not supposed to enter places of entertainment for 11 months. Uncle Monty

decided that a stadium, since it was out of
doors, was not covered by that law. So,
instead of going to the pictures he began to
go to football matches once or twice a week,
often at Highbury, and he sometimes took me
with him, which was wonderful, as I was an
Arsenal supporter. He also went greyhound
racing and here too sometimes took me with
him. I had grown up with horse racing, but
the dogs had an even more insidious appeal,
through my responsiveness to the magic of
numbers. I was enthralled by the huge
totalisator board at Wembley and became
fascinated by the arithmetic of tote betting.

Uncle Monty was neatly built with a
monkey face and a moustache. Where Sybil
was a *jolie laide*, he was an ugly ugly, but
attractive to women and greatly abetted in his
search for pleasure by an amazing chutzpah:
when Arsenal played Sheffield United in the
1936 Cup Final, I listened on the wireless
while Uncle Monty went to Wembley

ticketless but confident. He carried a big camera with him and he used it here, as he often did, to bluff his way in. He saw the match seated on the touchline a few feet away from the managers and he came back bearing a programme for me signed in the dressing-room by several Arsenal players.

Auntie Cissie, who bore him a son and a daughter, had actually come to this country in order to be married to him by arrangement. She was quite good-looking in a dark, sharpish way and was the best cook of Jewish food I have ever come across. But Uncle Monty wasn't the sort of man whose heart was to be reached through his stomach. I don't know whether Auntie Cissie was sexy, and suspect she wasn't; she certainly had no great sense of humour or adventure, and it all looked utterly inevitable when he went off with a beautiful slinky strawberry blonde *shikse* a lot younger and taller than himself called Josie, who married him and bore him a

blonde fairy princess whom he came to love
so fanatically when she grew up that she
could hardly bear the strain.

Around the beginning of the war, Uncle
Monty stopped merely dipping, as he always
had, into low life and stepped right into it. He
needed to make a good deal of money to pay
his alimony and support a fun-loving and
very *sortable* new partner, so he moved into
Soho as the manager of an all-night café in
Rupert Street. It meant his having to deal,
despite his size, with the roughest, toughest
characters in London, augmented by drunken
military, and he somehow handled this clien-
tele night after night without getting beaten
up. In his leisure time he and Josie patronised
the district's drinking clubs and sometimes
took me with them. I loved these places'
menacing, clip-joint atmosphere; at 17 I could
feel like someone in a Warner Brothers film.
There was one bar near the Regent Palace
where I rather fell for a young hostess from

Glasgow and spent all my money on buying her champagne. She was killed one night when the club was demolished by a bomb.

Monty's desertion of Cissie ended very well for her. She changed her name to Sonia and found a rich, good-natured Jewish widower some years older than herself whose heart was manifestly accessible via his stomach. Her old age was a long and comfortable widowhood. Monty paid a heavy price for winning a glamorous *shikse*. Their marriage lasted about ten years and once she left him his life went downhill. Actually, it was not so much a life as a lingering death induced by heavy smoking. His old age was quite long and very lonely. I ought to have done something to keep him company but failed him. He was one of two uncles of mine who became a sort of friend. The other was my father's youngest brother, Louis. He was a bachelor and a commercial traveller – in cigarette-vending machines, for example –

who always drove an interesting car: I especially remember a biggish Talbot coupé. He looked stylish at the wheel and got cheered one afternoon while driving with his hood down through some village where they mistook him for the Duke of Kent. We had much less to talk about than I had with Monty, but I liked him a lot for being the most secular of the Sylvesters. He was to spend the second half of his life in mental asylums. He too was someone I might have tried going to see and didn't. In this case it wasn't pure idleness; I was scared.

The most appealing of the Sylvester brothers was undoubtedly my namesake – the most appealing to my eyes and to everyone else's. Dave was appealing because he wasn't feared; that was his problem. He was quiet and gentle and so predictably gloomy it was a family joke. Running the same sort of business as most of the others, he was the one who was least prosperous, obviously because he lacked

drive and had scruples. I feel that even his gloom must have been relieved by the presence of his wife, Eva, a pert Russian beauty with curly red hair and green eyes who was by far the most lively, amusing and kind, as well as the most attractive of the Sylvester wives. We used to play cards quite a lot, the two of us, and that was enjoyable, not the cut-throat business that playing with my mother was, though that was, of course, sexier.

Among the other four couples, in ascending order of age, Sid and Vera, Harry and Iris, Jack and Clarice and Abe and Anne, the most interesting were easily Harry and Iris. Harry was admirable for no other reason than that he had enough style to own a Daimler coupé with pre-selective gears. He cried a lot when he listened to music and often kissed horses in the street. But he also had a habit of offering you a cigar, then taking it back to give you a better one which was always

inferior. Iris, *née* Breckman, was a blonde with serious Sephardic glamour and a taste for flirting with handsome young rabbis. They conspired in an event that depressed me deeply: the marriage of a delightful teenage daughter to a very rich South African heir who was going to take her off to Johannesburg; at the dinner dance at Grosvenor House I felt I was taking part in the ceremonial sacrifice of a young virgin to the god Mammon. The marriage didn't turn out well. Harry and Iris's own marriage was a brawl on a terrifying scale – no, not a brawl but a frenzy of rage.

But then rage was an emotion beloved of the Sylvesters. It was often seen at its most intense at the parental house in Greenfield Gardens, Cricklewood, in the 1930s, on a Saturday afternoon when several brothers were visiting. Terrible rows would develop between them. The sight of my father with his back up against a wall with three or four

of his brothers pushing him into it, shouting abuse, arms raised to smite him, made me feel extremely frightened for this normally dominant figure with all his power drained out of him. I knew my Old Testament, I knew of the capacity for envy and malignity of the chosen people. I knew that while Cain was a bad man, the development of serious expertise in fraternal villainy arrived with Jacob, a.k.a. Israel, and then his sons, Joseph's brethren.

One afternoon at the Regent Palace my mother and I were joined for tea by a suave thickset German with a deep tan and glossy thick black hair who handed me two presents: a paper knife the handle of which was covered in glossy antelope hide and a glossy brochure on the forthcoming Berlin Olympic Games. This meeting must by inference have occurred during the Easter holidays of 1936, though just possibly during the Christmas holidays before that. The brochure contained an annoyingly small number of photographs

of the previous Olympics, at Los Angeles in 1932, and an annoyingly large number of photographs of ancient Greek statues.

On the boat to Ostend that summer I fell into conversation with some Californians who were on their way to the Olympics. We discussed the race that obsessed me, the 1500 metres. They were convinced that the winner would be their man, Cunningham; I hoped it would be Lovelock, a New Zealander who was currently a doctor at a London hospital and whom I supported for being one of the breed of runners who win their races by coming from behind, like my favourite jockey, Harry Wragg, 'the head waiter'. Some months after the Olympics (Lovelock won), there was a morning, perhaps a Sunday, when a shouting match between my parents, not an unfamiliar noise, reached an unprecedented level and, moreover, was re-inforced by the sound of breaking glass. When the battle had subsided, I tiptoed down

to the dining-room and found the carpet littered with exploded oranges that had been used as grenades and with the fragments of a large and precious cut-glass vase. I gradually learned that two or three days earlier my mother, accompanied by Jac, had disappeared to Southampton and boarded a ship on which to sail to South Africa with the glossy German, whose name was Willy. With the ship about to depart, she had decided that she couldn't after all abandon Phil and me and had come home. Later she explained to me that she had been tempted to leave because Willy was so much kinder to her than Phil was. This was interesting in that she had often told me that, at the time when she had agreed to marry Phil, she had chosen him in preference to someone more attractive called Gerry because she thought Phil would be kinder to her.

He was never, never to forgive her for nearly leaving him. Obviously, most of his

anger came out of the torment of imagining
the loved one coupling with someone else, an
emotion that might have been further aggra-
vated by his ignorance that Sybil had been
habitually adulterous. But his anger also came
out of having been fooled, having been the
victim of a plot, having had people laughing
about him behind his back. He ranted again
and again against certain women in the
household for having 'condoned' her infidel-
ity by not reporting it to him. There was no
asking himself why they had been loyal to her
rather than to him. There was no asking
himself why she had wanted to leave him.

I wasn't aware at the time how far-
reaching the effects would be of the
affair with Willy. I think this was because the
crisis happened in the midst of a period at
Teignmouth Road which was volatile in
every way. The period between Grandpa's
disappearance and Grandma's death had been

pretty stable; the period between Grandma's
death and the war's break-up of the house-
hold towards the end of 1939 was one of
perpetual change. The major changes for me
personally were that, first, in the autumn of
1937 I moved from the top of a school with
sixty boys to near the bottom of a school with
six hundred, and, second, that puberty
arrived: by the end of 1937 there may have
been two or three occasions when I had
masturbated to orgasm; in 1938 there were
some days when I did so 15 times.

There was also a major change in the
membership of the nursery: I acquired
another sister, an elder sister. My Auntie Bec
had married a charming man called Tannen-
baum, the marriage had broken up, their three
children were farmed out to three of Bec's
brothers, and so Elise Tannen, as she called
herself, came to live with us. This might have
been bad for me, as I would now have to
contend with three females at the nursery

dinner table. But she turned out to be a friend. She was very helpful when at 12 I was enamoured of a black-haired, black-eyed, dimpled 11-year-old called Rita whom I had met at my sister's dancing class and about whom I felt desperately possessive at its annual concert when she gave a provocative performance of 'Heat Wave' (by comparison with the semitic fire of which Marilyn Monroe's version was pure Sunday School). Rita used to come to tea at Teignmouth Road and, when we played Postman's Knock, Elise would ensure that I got the chances to kiss her something like as often as I wanted to. Elise also served as my confidante. At the time of my passion for Rita I used to spend afternoons at the house of a schoolfriend a year older than myself called Gordon. We'd get on his bed and wrestle, naked from the waist down, sometimes with a pillow between us, sometimes not. And sometimes we'd put a couple of pillows on the bed and each rub up

against one. Neither of us ever went on long
enough, but the feeling was marvellous.
Gordon described it well: 'It's like bananas.'
One evening when Elise came to my bed-
room to say goodnight, I told her about these
thrills. Now, at that time my room was the
dressing-room adjoining my parents' bed-
room. Either my father was there and my
voice loud enough to be heard through the
door, or Elise betrayed me, but a day or two
later further visits to Gordon were forbidden
on the grounds that he was too old to be a
suitable friend.

Other newcomers to the household were
there as a result of the Depression, which was
biting harder year by year. So it was natural
that after Grandma's death one of the maids
had to go; what was less acceptable was that
we had to have a lodger. Only one of these
young women was actually hated by Jac and
me. This was the first of them, Ilse Meier of
Heidelberg, a student. She had a long white

face, abominable in its innocence, a great
many teeth, curly brown hair, a girlish voice
and a cheerful manner which reeked of self-
importance. She commandeered the tele-
phone, which sat in the hall, so that her voice
echoed through the house. 'Diss is Ilse Meier
from Heidelberg speaking.' Jac and I would
march up and down the nursery chanting
'Diss iss Ilse Meier from Heidelberg speak-
ing,' but the calls went on. At weekend
lunches and dinners we felt sick every time
she entered the conversation: she always
seemed so sure that the sound of her voice
would please. Among her successors was an
opera singer from Vienna called Mrs Ling
who, as I discovered from carefully timed
peeps through the keyhole of her bedroom
door, had a chubby little figure and a lovely
bush.

There were, of course, tragic implications
to the presence in London at this time of the
likes of Miss Meier and Mrs Ling. They

belonged to the small army of refugees who
arrived after Hitler took power. Those who
entered our lives, besides the lodgers and
Willy and a young lawyer who became my
Hebrew teacher, were two or three Austrian
couples whose immigration my father had
ensured by acting as a guarantor and who
regularly came to the house on Friday nights.
There was also the amazing family who
bought the house next door. The father was a
tiny man in a dressing-gown who had wiry
white hair and looked like a mad scientist in a
German Expressionist film. He was Dr Laza-
rus Goldschmidt, an eminent Biblical and
Talmudic scholar, an occupation that did not
make him a believer. The son of the house,
Emmanuel, known as Mani, was about three
years older than me and had been boarding
since 1933 at the Perse School in Cambridge,
where from the start parcels had been arriving
for him from Germany of so-called school-
books which were in fact the contents of a

library that included many medieval manu-
scripts and incunabula. Mani and I met a lot
in the holidays to use a full-sized billiard table
in his house. Later he married Elise.

The onset of war in September 1939
brought about the break-up of that household
at Teignmouth Road. Looking back, I realise
that in fact I spent very little waking time
there during the final two years, that is, once I
had moved to my public school, and that that
could well have been as much from a
disinclination to be there as from the pull of
other places. I often stayed late at the playing
fields, or on other evenings stayed on at the
school itself to use the tennis courts or gym
or do my prep, and I also habitually visited
other boys' houses to play ball-games or
pontoon or gramophone records.

My only recollection of life at our house
itself during those last two years dates from a
Saturday during that final summer, so full of
foreboding, when lunch was cooked and

served by a maid who had arrived that week,
a quiet, shy girl straight from Ireland who
couldn't have been more than 16, even 15, and
had a long, pale, delicately pretty, vapid face
with blue-green eyes and red hair. Lunch
included my favourite pudding, jelly. And the
silly girl served it on hot plates so that it was
melting. I was outraged. What was she doing
daring to come and cook for people when she
was so stupid? Later Elise told me she
suspected that the girl had a crush on me. I
felt both guilty and foolish: the annoyance I
had shown in front of her could have scared
her away. It probably made no difference, for
this was an Irish maiden surely full of the fear
of hellfire, and anyway I wouldn't have
known how to proceed: fondling the breasts
of one or two more boisterous girls hadn't
taught me enough. What did matter – though
of course I wasn't aware of it at the time –
was how far I'd shown myself to be my
father's son: someone who saw other people

as potential targets for disapproval rather than potential accomplices in pleasure.

The school I have referred to as my 'public school' was, like my prep school, a day school in North-West London. I left Vernon House, Brondesbury, for University College School, Hampstead, in the summer of 1937. UCS was third choice among the schools I might have gone to, the first having been Westminster, the second, St Paul's. Given my parents' financial difficulties at the time, I needed to win a scholarship that would cover at least half my fees. It was thought more likely that I'd succeed in this at UCS than at the top schools; moreover, if I got a half-scholarship at one of these, the fees still to be paid would be substantial. So it was decided that I'd try for UCS, and I won a half-scholarship there, largely thanks to good papers in history, Latin and mathematics. The problems were, what I was going to specialise

in and what I was going to do when I grew
up. It was decided, not by me, that I was
going to be a lawyer and therefore I ought to
start learning Greek.

In my first end-of-year exams my percent-
age mark for Greek was a single figure, and
this was not the only subject in which I had
learned nothing. My monthly grades had been
Cs and Ds and occasionally Es; furthermore,
I had earned a reputation for subversiveness.
In the end-of-year exams, however, to the
annoyance of the teachers, I came top in
algebra and third in arithmetic and in Latin,
entirely by drawing on what I'd learned at
Vernon House. The one area into which I put
serious effort was my English essays, but my
English master didn't like their style. For my
second year I was shifted to the mathematics
side; it was thought that I might become an
actuary. In fact, I acquired a passionate
interest in a subject new to me, chemistry. I
spent all my pocket money on chemicals and

equipment and decided that I was going to be an analytical chemist: I was well content as I approached 15 with the prospect of an obscure career in the sciences – I liked the sound of 'analytical chemist'.

One reason I was a misfit was that it was a burden to be an Entrance Scholar: you went through school with an asterisk against your name on every printed list, and you were expected to be accomplished and even virtuous. Given my failures, it was not at all surprising that the school two or three times suspended my scholarship for a term. But perhaps the main distraction from work was not something negative but sheer love of ball-games, for which I was suddenly being provided with all sorts of facilities. The conventional wisdom divides boys into aesthetes v. athletes or swots v. louts, but things aren't always as simple as that. I wasn't 'good at games', but I gave them my best energies. And sometimes I even did well. In a

handicap tennis tournament my usual doubles partner and I drew the school's top pair, the brothers Carlson, John and Frank, as our opponents in the first round. They had to give us two points a game, and we won. There was quite a stir of disbelief around the school notice-board the following morning: here was fame at last. Even better, two or three years later Frank Carlson won the Junior Championship at Wimbledon. Better still, in 1949 my girlfriend took an overdose and on the way to the hospital I feared she might be prosecuted if the doctors reported the matter to the police. The houseman who received us was my tennis partner. Nothing was said, even among ourselves. That is why I have been unable to name the dear fellow.

There were also some good moments on the cricket field. In a junior house match in my first year I shared in a stand of more than fifty for the sixth wicket which won the game from a losing position; in another in my

second year, I shared in an opening stand which had all but equalled the other side's score before I got out. What mattered still more to me, I opened the bowling in a practice match and took six wickets for seven runs. It did me no good: people wouldn't take my bowling seriously because I had an eccentric action, bowling off the wrong foot.

As we holidayed in Brighton in August and September 1939, expecting that we'd soon be at war, I think that the general view of the impending Armageddon was very much shaped by the film *Things to Come*: within days Piccadilly Circus would be looking like the Roman Forum. In consequence, the future seemed particularly threatening for those who lived in the capital. The general supposition was that Brighton was going to be a lot safer than London, and our lives were quickly reorganised on this assumption. It

was decided to open a shop in Brighton and shut down the three in different parts of North-West London, because it seemed unlikely that their clientele of well-off Jews would hang around there waiting for the bombs to drop. So my mother stayed on in Brighton to manage the new shop (she had previously only worked as a part-time cashier), while my father returned to the house in London so that he could continue to do the buying at Billingsgate, abetted by his van driver, Jim Ingerfield (a very nice man who would often let me steer his van; it was only later, when I tried to deal with the gears as well, that I gave up the wish to drive). My sister stayed on in Brighton, and at first there was some investigation of my moving to Brighton College or Brighton Grammar School. But news came that UCS was one of the London schools which had decided to stay put and, as I was on the verge of my School Certificate year, it was thought best that I

continue there. So I went back to Teign-
mouth Road, to share a house with Phil and a
cook-housekeeper, helped by a daily maid,
and a charming male lodger called Dr Schäler
who had been the Head of a Gymnasium in
Austria and was now working as a booking-
office clerk (a fate that has haunted me ever
since).

Though there were several empty bed-
rooms in the house, my father insisted that I
share his double bed. It seemed odd that a
middle-aged man would feel lonely sleeping
on his own, and I found the closeness of his
body disagreeable, even threatening: I
wouldn't even have wanted to sleep so close
to one of the boys with whom I played sexual
games in the school crypt or on Hampstead
Heath; there, things were under control, one
wasn't vulnerable. As if lying in the dark next
to one's own father were not disturbing
enough, he, having secured my presence,
demanded my attention. He talked and talked;

there was no going to sleep. The subject was my mother's infidelity, and in his anger and self-pity he droned on and on, hour after hour, night after night, week after week. The only infidelity he seemed to be referring to was the affair with Willy: I do not know to what extent he ever discovered that there had been others, even many others. I didn't and don't know whether I was the only person in his life to whom he confided these sufferings. I didn't and don't know whether he had chosen me for this role with sheer indifference to how this nightly torture might affect my work and health or out of a positive wish to make me share his hatred of my mother: it was probably the former, probably inspired by desperation rather than malice. Obviously it didn't occur to him that an adolescent boy was not going to understand the torments of a family man whose contentment had been torn apart, nor, indeed, understand the nightmares of sexual jealousy. We weren't even speaking

the same language. From time to time I
would suggest that, if it was now so intoler-
able to be married to my mother, he could get
a divorce. This would be answered with a
lamentation to which I would reply by saying
that if he didn't like being divorced, he could
always remarry, and when I said this, I was
thinking, in my naivety, of his remarrying my
mother.

As it was always very late before I got to
sleep, it was impossible to get up in the
morning and difficult to get to school on
time. I didn't like this because boys who
arrived too late for Prayers were interviewed
by the Vice-Master, who happened to be Mr
Oliver, my chemistry teacher, whose approval
I craved. I therefore got into the habit of not
turning up at all and of forging notes to
excuse my absence through illness: this some-
times went on for a week or more at a time.
My daily programme went something like
this. I'd go to an amusement arcade in

Memoirs of a Pet Lamb

Kilburn, one at which I'd mastered certain tables, and play till I'd won my day's ration of cigarettes. I would then wander around gramophone shops and departments all up the Edgware Road and along Oxford Street listening to jazz records but never buying one. In the afternoon I'd go to the cinema. Having no homework to do, I was often allowed to go to the cinema in the evening too: there was one week in which I saw 15 feature films.

After five or six weeks had passed, I started, whether I was at school or on the town, to feel abdominal pains. These began as pangs of hunger, much more intense than those of normal hunger, which went away as soon as I had something to eat or a glass of milk, but after a while were replaced by another sort of pain. After a couple of weeks of this I told my father about it, and he called a doctor, who, when I reported my symptoms, looked surprised and immediately

[78]

arranged an appointment at Willesden General Hospital. It was for a barium meal X-ray, and this showed that I had a duodenal ulcer. I was put on a diet, told I needed a period of complete rest for several weeks and was sent to join my mother and sister on the coast till the end of term. My mother had rented a large ground-floor flat in Hove and acquired a maid called Audrey, petite and extremely pretty, with dark brown hair and large blue eyes, in her late twenties and separated from a husband. Audrey was a good name for her because for some years there had been a series of usually dirty jokes in circulation which always ended: 'And little Audrey laughed and laughed and laughed, because she knew that etc., etc., etc.' Our Audrey took a lead from this by being provocative. 'Put yours against mine,' she'd say as she lit a cigarette from the tip of my cigarette. And she greatly enjoyed my frustration that that was all the putting together I got. Otherwise life in Hove was

pleasant. I played a lot of snooker.

Meanwhile, I had missed about half a term's work. The missed work included crucial ground in mathematics, my supposed forte, and I was only a term and a half away from the School Certificate exam. Obviously I should have stayed on in Hove and switched to a local school, but my parents evidently didn't stop and think about the realities of the situation, and I contributed to that through total inability to talk to my mother or anyone else about my father's behaviour. And so I was sent back to London.

At least there was not much more of the dripping tap of talk in the double bed, for after a while my father shut up Teignmouth Road and he and I went to stay in separate rooms at his mother's. She had lately been widowed in a ghastly fashion: my grandfather had been suffering for some time from cancer of the throat; the pain had become more and more unendurable and one day he had hanged

himself from the banisters. This was now
followed by the nightmare of my father's
rows with his mother. He seemed to be
constantly screaming that she was a witch –
something he could never bear to admit when
I brought it up in later years in answer to
accusations from him that I didn't honour my
parents. Also, she cooked, every morning for
breakfast, a fried egg of a disgusting greasi-
ness. Meanwhile, I was lost. I had missed too
much work and couldn't cope with the
calculus. The truancy began again, intermit-
tently. At the end of term the school decreed
that there was no point in my coming back
for another.

That decision might well have been
reached anyway, but the school did in fact
find out about the truancy. That could have
been through circumstantial evidence, but I
did hear that someone had caught sight of me
walking in Oxford Street in school hours and
had informed the school. She was the mother

of a boy at UCS a year senior to myself, a sanctimonious boy who had always been held up to me as a paragon with a promising future in law. The whole family were dedicated exponents of Anglo-Jewish middle-class respectability. They were supposedly friendly with my parents, yet they chose to report my delinquency not to them but to the school. Two years later the model son, while cleaning his rifle, accidently killed his father.

There was more justice in my sacking than in the subsequent behaviour of the Head Master. In 1944 he was required to write a reference for me for a job (which by a curious coincidence was seen by a friend). Presumably in order to imply that I was unwholesome, he stated that I'd shown no interest in games! He then went on to say something true: that I had recently been contributing to 'a left-wing publication' – a phrasing doubtless calculated to make me sound a menace to society. The publication was in fact *Tribune*,

when Aneurin Bevan was its editor and George Orwell its literary editor. That I was writing about art and occasionally literature for a leading weekly review within three years of being chucked out of school could reasonably have been seen as a sign of regeneration; he chose to present it as a symptom of degeneracy. His career at UCS was to be cut short by suicide – but I'm afraid all this is beginning to sound like *Kind Hearts and Coronets.*

Acknowledgments

This Memoir first appeared in the *London Review of Books*, 5 July 2001. Before his death, David Sylvester asked us to add that he was indebted to Grey Gowrie for some fundamental and indispensable advice.